Fresh Seeing

Fresh Seeing

Two addresses by
Emily Carr

With a preface by
Doris Shadbolt
and an introduction
to the 1930 speech
by the late
Ira Dilworth

Clarke, Irwin
& Company Limited
Toronto, Vancouver

ISBN 0-7720-0567-2

Cover Photo by Richard Wright,
courtesy Information Canada
Photothèque

Printed in Canada
2 3 4 5 / 79 78 77 76

Foreword

One of the displays in the Centennial Exhibition of
Emily Carr's work was the text of a speech the artist
made in 1930 to the Women's Canadian Club in
Victoria. In response to the interest this aroused, and
as a tribute to Miss Carr, Clarke Irwin is pleased to
republish the address, together with the text of a
speech she delivered five years later to an audience
in the Normal School.

The preface to this book was very graciously
provided by Mrs. Doris Shadbolt of the Vancouver
Art Gallery, who organized the Emily Carr Centen-
nial Exhibition and prepared the catalogue for it.
The publishers wish to express their warm apprecia-
tion for her courtesy and co-operation in this matter.

Preface

This publication of Emily Carr's two talks on art is an indication of the renewed interest in that great Canadian woman stimulated by the passing of the centennial anniversary of her birth in 1971, a welcome addition to her own published writings and to the literature that adds to our understanding of her.

Both belong to the time of her full maturity as an artist. In the five years which separate them, she had moved in her painting from deep dense totem and forest experiences to open, expansive spaces and swirling skies, having discovered, in the large, quick-drying oil-on-paper paintings, the sketching technique her expanded vision demanded. However, despite her statement that the material of the first talk she found to be no longer useable five years later for the second, the substance of the two is essentially the same.

Not only are these the only two public talks on art Emily Carr ever gave, one feels they were the only talks she had in her to give. She was not verbal or analytical about her art. And we know, from her journals and from the first-hand reports of friends and acquaintances, that she could become very impatient with those who were, or wanted to be. In fact, she felt she should not be giving the talk at all because she was only a worker, "and workers should work and talkers should talk, and both had best stick to their own jobs and avoid getting mixed up."

Nor was she a reader, at home in the realm of current ideas and theories of art. "I wish I was better at talking. . . . It is very difficult for me. I can't find what I want to say in books and copy it out because

lots of it I don't believe and lots I don't understand and lots doesn't interest me."* So her quotations, direct or indirect, from the books she has found useful, are like conspicuous marker-buoys she has found to cling to as she tries swimming in the unfamiliar waters of aesthetics.

Looked at as statements of aesthetics, her views of art tend to appear simplistic. But read, as they must be, as statements of her own hard-won convictions and insights as artist and person, they ring passionate and true. For, as someone who "hates like poison to talk," this must be the basis of her willingness to do so: she was a person of intense conviction, willing to give testimony of her faith. One suspects that she was also making the kind of generalized statement which artists do make at certain in-between times in their own creative cycle — the time of the cocoon-building, so to speak — of slow in-weaving of images, words, ideas, impressions out of which a new phase of creation will eventually emerge. Naturally she speaks out of the prevailing ideology of her time, reaching for worthy moral sentiments but using her own plain phraseology and often homely metaphor. Fortunately for her, she was incapable of artistic dishonesty — that is, allowing her words (or her brush) to lose touch with her intuitive feelings for things, her own grasp of reality. And so she presents, in simple terms, her verbal talismans for her beliefs, her understanding of fundamental artistic truths. She stresses the need to seek the "power behind the thing"; the "essentials," not the details; "aesthetic emotion"; the "soul of the thing"; the "life force"; and so on.

*From a letter to Eric Brown, Director of the National Gallery, 1937

Apart from her work, there are many aspects of Emily Carr's totality that are found to be relevant to our present needs and sensibilities: her strong identification with nature, her independent life-style, her sympathy for the eccentric, her scorn of convention. But to us of today's generations, lamenting our fragmentation, often semi-paralyzed with information and intellectualization, perhaps nothing is more appealing than just her wholeness, the unifying imprint on all she does or says of her own particular "life force" — of which these talks are yet another welcome manifestation.

DORIS SHADBOLT

Vancouver, British Columbia
1972

Fresh Seeing

Introduction

On 4 March 1930 (almost exactly 15 years before her death on 2 March 1945) Emily Carr made, as far as I know, her only formal public address* The occasion was a meeting in the Crystal Garden of the Victoria Women's Canadian Club — the meeting to celebrate Emily Carr's first one-man show in her native city.

There is plenty of evidence that the occasion was considered to be an important one. In spite of the fact that she was always scornful about "talk" in connection with painting, Miss Carr herself was very excited by the invitation to speak and took great pains in the preparation of her address — it survives in a perfectly "clean" typescript. She was troubled during the preparation of the talk by the fact that her beloved monkey, Woo, was taken violently ill. While Emily was occupied with writing the address, Woo appropriated and devoured a tube of yellow paint, and, despite the efforts of a veterinary and everything Emily could do herself was in very serious condition. A day before the event Emily refused flatly to give the talk unless Woo was better, and indeed it was only a few hours before the time for the address that she finally agreed, Woo having taken a definite turn for the better. She has made an amusing and, at the same time, pathetic reference to this experience in "The Life of Woo." Its closing sentences are: "The talk went over on the crest of such happy thanksgiving, it made a hit. The credit belonged to Woo's tough constitution."

Two days prior to the address the Victoria *Daily Colonist* carried an interesting article by Ludewyck

*Mr. Dilworth was incorrect on this point.

Bosch, an artist and critic visiting in Victoria. He spoke of his amazement on first seeing the paintings of Emily Carr and of his astonishment that they were not better and more favourably known by Canadians. He also noted the fact that an exhibition was being held. He said: "We are really very glad to hear that through the medium of the Women's Canadian Club an exhibition of Miss Carr's work will be held at the Crystal Garden on March 4th. While this exhibition is for one day only we have no doubt that the Canadian government, which has already done so much for Canadian art, will not let this opportunity pass unnoticed. Certainly it will know how to acknowledge and honour its great artists."

Whether the credit must go to Woo and her tough constitution or not, the address was a great success. Both the Victoria daily papers gave it wide publicity in their issues of 4 March. The *Daily Colonist* said in part: "An eloquent plea for a more tolerant and sympathetic view of modern art was made by Miss Emily Carr, a Victoria artist, who is at the same time one of Canada's recognized leading exponents of the new movement, in the course of an address which she gave yesterday afternoon before an audience which filled the Crystal Garden concert hall to its utmost capacity. In her exhibition of fifty or more canvases depicting West Coast Indian totems and village scenes, Miss Carr had an even more powerful argument than she advanced in her searchingly clever, humorous and analytical talk, although the latter helped many to examine the pictures with a fresh understanding and appreciation. The tremendous

interest which the subject has for Victorians was amply demonstrated in the unusually big attendance, which constitutes something in the nature of a record in the club annals. And the eagerness of many nonmembers to see the pictures has resulted in arrangements being made by the Crystal Garden management to continue the exhibition today and tomorrow from 10 a.m. to 5 p.m. daily."

These comments were paralleled by the Victoria *Daily Times*. After a quite lengthy quotation from the address, the *Times* reporter went on to say: "The foregoing summarizes the earnest plea made by Miss Emily Carr, noted Victoria artist, before the Women's Canadian Club yesterday afternoon for a greater spirit of tolerance and understanding towards the modern artist who, striving to portray not merely the photographic delineations of Canada's beauty, but the very spirit and soul of its majestic appeal, deserts the traditional school of art for that of the impressionist.

"Miss Carr's plea was made the more forceful by the exhibition of her pictures, held in the Crystal Garden gallery, in conjunction with the address. Two distinct phases in the development of her art were apparent in the collection, the first, while virile and powerful in design, tending more to the 'photographic' interpretation of scenes at the Indian villages on the west coast and in other parts of the Province, while her later work showed a groping after and a conception of the spirit underlying the primitive art of the Indians, as expressed in her amazing studies of totem poles. The pictures will remain on view to

the public at the Crystal Garden gallery today and tomorrow from 10 until 5 o'clock."

The address is typical of Emily Carr. It is forthright, challenging, down-to-earth, witty. It reflects the philosophy of her whole life as a painter, a philosophy which was centred around an insistence on complete integrity, independence, and honesty, a philosophy which she adhered to, lived and worked within throughout her whole career. She believed firmly that the artist must speak clearly to people, must speak in terms of actual experience but must address particularly the spirit and the soul. She was always, and increasingly in her middle and later years, opposed to photographic realism in painting. She felt that there was a much higher role for the true artist and of this he must be aware, and this role he must play.

There is a most interesting brief passage in one of Emily's "Journals" where she put the whole thing very clearly: "Be careful that you do not write or paint anything that is not your own, that you don't know in your own soul. You will have to experiment and try things out for yourself and you will not be sure of what you are doing. That's all right, you are feeling your way into the thing. But don't take what someone else has made sure of and pretend it's you yourself that have made sure of it, till it's yours absolutely by conviction. It's stealing to take it and hypocrisy and you'll fall in a hole. . . . If you're going to lick the icing off somebody else's cake you won't be nourished and it won't do you any good — or you might find the cake had carraway seeds and you hate

4

them. But if you make your own cake and know the recipe and stir the thing with your own hands it's your own cake. You can ice it or not as you like. Such lots of folks are licking the icing off the other fellow's cake!"

The address which is now published for the first time and the notices in the contemporary press of Victoria are interesting and significant. They show a degree of public interest in Emily Carr's work as a painter which has perhaps not always been realized as existing at so early a date as 1930. True, she had had her exhibition in Ottawa some four years earlier. She had contributed single canvases to exhibitions in Eastern Canada, in Vancouver, in the United States, and even in Europe, but the Victoria exhibition of her paintings together with the opportunity given her to speak of her work is a very important point in the history of public reaction to her painting. Unfortunately, the interest indicated in the newspapers was not sustained and Miss Carr had a long period of struggle and only semi-recognition ahead of her. Indeed, final recognition did not come until her books began to be published by the Oxford University Press — the first of them, *Klee Wyck*, in 1941. This volume and others that followed attracted a new kind of attention from a new group of people to the work of this extraordinary woman.

I am very grateful to be associated with the Oxford University Press in the publication of this unusual address in this tenth anniversary year of Emily Carr's death.

<div align="right">IRA DILWORTH</div>

Vancouver, British Columbia
1955

Fresh Seeing

I hate like poison to talk. Artists talk in paint — words do not come easily. But I have put my hate in my pocket because I know many of you cordially detest "Modern Art." There are some kinds that need detesting, done for the sake of being bizarre, outrageous, shocking, and making ashamed. This kind we need not discuss but will busy ourselves with what is more correctly termed "Creative Art." I am not going to tell you about the *'ists* and *'isms* and their leaders, and when they lived and when they died. You can get that out of books. They all probably contributed something to the movement, even the wild ones. The art world was fed up, saturated, with lifeless stodge — something had to happen. And it did.

I want to tell you some of the things that I puzzled about when I first saw it and wondered what it was all about. It stirred me all up, yet I couldn't leave it alone. I wanted to know why. When I went to Paris in 1911 I was lucky enough to have an introduction to a very modern artist. Immediately I entered his studio I was interested. Later I took lessons from him. Yet, strange to say, it was his wife, who was not an artist at all, that first gave me very many of the vital little sidelights on modern art. She really loved and appreciated it, not for her husband's sake (they scrapped), but for its own sake. She evidently admired his work more than she admired him. He was a fine teacher and his work was interesting and compelling, but his wife read and thought and watched, and she had the knack of saying things.

To return to the term "Creative Art." This is
the definition a child once gave it: "I think and then
I draw a line round my think." Children grasp these
things more quickly than we do. They are more
creative than grown-ups. It has not been knocked out
of them. When a child draws he does so because he
wants to express something. If he draws a house he
never fails to make the smoke pour out of the
chimney. That moves, it is alive. He feels it. The
child's mind goes all round his idea. He may show
both sides of his house at once. He feels the house
as a whole, why shouldn't he show it? By and by he
goes to school and they train all the feeling out of
him. He is told to draw only what he sees, he is
turned into a little camera, to be a mechanical thing,
to forget that he had feelings or that he has anything
to express; he only knows that he is to copy what is
before him. The art part of him dies.

The world is moving swiftly and the tempo of
life has changed. What was new a few years back is
now old. There have been terrific expansions in the
direction of light and movement; within the last few
years these have altered everything. Painting has
felt the influence. Isn't it reasonable to expect that art
would have to keep pace with the rest? The romantic
little stories and the mawkish little songs don't
satisfy us any longer. Why should the empty little
pictures? The academic painting of the mid-
nineteenth century in England had entirely lost
touch with art in running after sentiment.

When Paul Cézanne, the great Frenchman who
did so much to show the world that there was

8

something so much bigger and better for art, came, he was hooted at, called crazy, ridiculed! Now we realize what he and the men who followed him did to open the way, to change our vision. Cézanne's real *NB* business was not to make pictures, but to create *my painting* forms that would express the emotions that he felt for what he had learnt to see. He lost interest in his work as soon as he had made it express as much as he had grasped.

Lawren Harris says: "The immediate results of 'Creative Art' are irritating and foreign." One thing is certain — it is vital and alive. The most conservative artists, although they may rant and rail, are consciously or unconsciously pepping up their work. They know that if they do not, it is going to look like "last year's hat" when it goes into the exhibitions. They are using more design, fresher colour, and the very fervour with which they denounce Modern Art shows how it stirs them up. So also with the onlooker. It may stir and irritate him, but isn't it more entertaining and stimulating even to feel something unpleasant than to feel nothing at all — just a void? There is such a lot of drab stodginess in the world that it's delicious to get a thrill out of something.

Willinski says: "A high proportion of the naturalistic painting of the world was done in the nineteenth century, due partly to the fact that the invention of the camera greatly enhanced this technique." Certain of the camera's limitations are now universally admitted.

1 The camera cannot comment.
2 The camera cannot select.

3 The camera cannot feel, it is purely mechanical.

By the aid of our own reinforcement we can perceive roughly what we desire to perceive and ignore, as far as is physically possible, what we do not desire to perceive. No work of real value is produced by an artist unless his hand obeys his mind. The camera has no mind.

We may copy something as faithfully as the camera, but unless we bring to our picture something additional — something creative — something of ourselves — our picture does not live. It is but a poor copy of unfelt nature. We look at it and straightway we forget it because we have brought nothing to it. We have had no new experience.

NB Creative Art is "fresh seeing." Why, there is all the difference between copying and creating that there is between walking down a hard straight cement pavement and walking down a winding grassy lane with flowers peeping everywhere and the excitement of never knowing what is just round the next bend!

Great art of all ages remains stable because the feelings it awakens are independent of time and space. The Old Masters did the very things that the serious moderns of today are struggling for, namely, trying to grasp the spirit of the thing itself rather than its surface appearance; the reality, the "I Am" of the thing, the thing that means "you," whether you are in your Sunday best or your workday worst; or the bulk, weight, and impenetrability of the mountain, no matter if its sides are bare or covered with pine; the bigger actuality of the thing, the part that is the same no matter what the conditions of

10

light or seasons are upon it — the form, force, and volume of the thing, not the surface impression. It is hard to get at this. You must dig way down into your subject, and into yourself. And in your struggle to accomplish it, the usual aspect of the thing may have to be cast aside. This leads to distortion, which is often confused with caricature, but which is really the emotional struggle of the artist to express intensely what he feels. This very exaggeration or distortion raises the thing out of the ordinary seeing into a more spiritual sphere, the spirit dominating over the subject matter. From distortion we take another step on to abstraction where the forms of representation are forgotten and created forms expressing emotions in space rather than objects take their place; where form is so simplified and abstracted that the material side, or objects, are forgotten — only the spiritual remains.

This use of distortion accounts for the living qualities in many of the Old Masters — the dear, queer old saints with hands and faces and bodies all distorted, but with their spirits shining through with such a feeling of intense beauty. It was not that these men could not draw. Do you think that their things would have lived all through the centuries if there was nothing more to them than bad drawing? It was the striving for the spiritual above the material. Had they made the bodies ordinary the eye would have been satisfied with the material side. It would have looked no further and would have soon tired. But, being raised up above the material, the spiritual has endured and will for all ages. The early Christian

11

artists, seeking to perceive an aspect of man suitable for a divine image, thought away the flesh and distorted the human body to make it as uncorporeal as possible.

As the ear can be trained by listening to good music, so the eye can be trained by seeing good pictures.

People complain that modern art is ugly. That depends on what they are looking for and what their standard of beauty is. In descriptive or romantic art they are looking for a story or a memory that is brought back to them. It is not the beauty of the picture in itself that they observe. What they want is the re-living of some scene or the re-visiting of some place — a memory.

The beauty concealed in modern art consists more in the building up of a structural, unified, beautiful whole — an enveloped idea — a spiritual unity — a forgetting of the individual objects in the building up of the whole.

By the right disposition of lines and spaces the eye may be led hither and thither through the picture, so that our eyes and our consciousness rest comfortably within it and are satisfied. Also, by the use of the third dimension, that is, by retrogression and projection, or, to be plainer, by the going back and the coming forward in the picture — by the creation of volume — we do not remain on the flat surface having only height and breadth but are enabled to move backward and forward within the picture. Then we begin to feel space. We begin to feel that our objects are set in space, that they are

surrounded by air. We may see before us a dense forest, but we feel the breathing space among the trees. We know that, dense as they may appear, there is air among them, that they can move a little and breathe. It is not like a brick wall, dead, with no space for light and air between the bricks. It is full of moving light playing over the different planes of the interlocked branches. There are great sweeping directions of line. Its feelings, its colour, its depth, its smell, its sounds and silences are bound together into one great thing and its unfathomable centre is its soul. That is what we are trying to get at, to express; that is the thing that matters, the very essence of it.

There are different kinds of vision. The three most common are practical, curious, and imaginative. Because these are habitual in daily life we have become accustomed to use them when looking at pictures, and all three of them cause their owner to be interested in practical matters, in the data which the picture records, in matters of skill, in story-telling, etc. If anyone using only these three types of vision looks at a picture in which the trees have, let us say, been made universal instead of particular (that is to say, in which they have had all their pictorial, meaningless branches and wiggles omitted and the essential shape then changed to meet the needs of design), he is more or less incensed. His practical vision at once asks: What are they? When told they are trees, he is angry and says: "They don't look like it." The fact that the artist has aimed at another goal than that of copying is beyond his comprehension. It doesn't exist for a person using only these three types of vision.

The attainment of further adventure in seeing pictures depends on what is called pure vision. This is the vision that sees objects as ends in themselves, disconnecting them from all practical and human associations. In that direction only lie the new horizons which have been revealed for us by the modern movement. All forms in nature can be reduced to primary geometric solids — that is, a mountain may be represented by a cone or pyramid, a tree-top as a cube or sphere, the trunk as a cylinder. So to reduce such objects for purposes of pictorial design simplifies the problem to its lowest possible terms. When a picture is looked at, the relation of its forms and spaces should be felt emotionally rather than thought about intellectually. Today we have almost lost the ability to respond to pictures emotion- ally — that is, with aesthetic emotion. Modern art endeavours to bring this ability to consciousness again.

The question of things not looking what they are is often a stumbling block to the observer who would like to understand modern art. There may be a bigger thing that the artist is striving for in his picture than the faithful portraying of some particular trees or other objects. It may be some great emotion that he feels sweeping through the landscape. We will say there is a high mountain of overpowering strength in his picture that seems to dominate every- thing, to make the rest cower and shrink. Possibly that is the thing he focuses his attention on, the thing he is trying to express. He sacrifices everything to that emotion, changing his forms, selecting, omitting, bending every other thing to meet that one desire.

Everything in his picture must help to envelop
and unify his idea.

It would, I feel, be impossible to speak on Canada
and creative art without mentioning the Group of
Seven and the splendid work they have done and
are doing for art in Canada.

Some of you will have read the *Canadian Art
Movement* by F. B. Housser. It is in our Public
Library, which, by the way, has some very helpful
art books. The Yearbook of Canadian Art* by
Bertram Brooker and *Modern French Painters* by
Jan Gordon — these books and others are a great help
to those isolated as we are from the big art centres
of the world. The Provincial Library, also, has some
fine books on art and doubtless the librarians, if they
find sufficient interest is taken in this subject, will
add more. The Group of Seven consists of a small
group of men, some with academical training, some
without; most of them are Canadian by birth, all are
Canadians in the best sense of the word. They were
mostly busy men with livings to make, but they loved
art and in their holidays they went up to the country
above Lake Superior to paint and were enthralled
by it, put their best into it and took the best out of it.
I will quote what one of their members, Lawren
Harris, says of their evolution: "The source of our
art is not in the achievements of other artists in other
lands, although it has learned a great deal from these.
Our art is founded on a long and growing love and
understanding of the North, in an ever clearer
experience of oneness with the informing spirit of
the whole land and a strange brooding sense of

*Bertram Brooker, *Yearbook of the Arts in Canada*,
 Toronto, 1929, 1936.

Mother Nature fostering a new race and a new age. So the Canadian artist in Ontario was drawn North and there at first devoted himself to Nature's outward aspect, until a thorough acquaintance with her forms, growth and idiosyncracies and the almost endless diversity of individual presences in lakes, rivers, valleys and forests, led him to feel the spirit that informs all these. Thus, living in and wandering over the North and at first more or less copying a great variety of motives, he inevitably developed a sense of design, selection, rhythm and relation to individual conformity to her aspect, moods and spirit. Then followed a period of decorative treatment of her great wealth and design and colour patterns, conveying the moods of seasons, weather and places. Then followed an intensification of mood, that simplified form into deeper meaning and was more vigorously selected and sought to have no element in the work that did not contribute to a unified, intense expression. The next step was the utilization of the elements of the North in depth, in three dimensions, giving a fuller meaning, a more real sense of the presence of the informing spirit."

These men are a group that Canadians may well be proud of. They have opened up wonderful fields for art in Canada, burst themselves free, blazed the trail, stood the abuse and lived up to their convictions. At Wembley in 1924 their work was recognized by critics familiar with the best modern work of Europe. Later they exhibited by invitation in Paris as well as all the big centres in the United States. One of the splendid things about them is their willingness

to help those who are struggling to see things in a
broader way.

What about our side of Canada — the Great West,
standing before us big and strong and beautiful?
What art do we want for her art? Ancient or modern?
She's young but she's very big. If we dressed her in
the art dresses of the older countries she would burst
them. So we will have to make her a dress of her
own. Not that the art of the Old World is not great
and glorious and beautiful, but what they have to
express over there is not the same as we have to
express over here. It is different. The spirit is
different. Everyone knows that the moment we go
from the Old Country to the New, or from the New
to the Old, we feel the difference at once. European
painters have sought to express Europe. Canadian
painters must strive to express Canada. Misty
landscapes and gentle cows do not express Western
Canada, even the cows know that. I said to a farmer
in Scotland once: "That fence wouldn't keep out a
Canadian cow." "You are right," he replied, "it
would not. Your cows are accustomed to fighting their
way through the bush. When they are shipped here,
it takes twice as many men and twice as high a fence
to make them stay put." So, if the country produces
different cow-spirit, isn't it reasonable that it should
produce different artist-spirit? Her great forests, wide
spaces, and mighty mountains and the great feel of
it all should produce courageous artists, seeing and
feeling things in a fresh, creative way. "Modern" we
may call it, but remember, all modern art is not jazz.
Canada wants something strong, big, dignified, and

spiritual that shall make her artists better for doing it and her people better for seeing it. And we artists need the people at our back, not to throw cold water over us or to starve us with their cold, clammy silence, but to give us their sympathy and support. I do not mean money support. I mean moral support; whether the artists are doing it in the old way or in the new way, it does not matter, so long as it is in the big way with the feel and spirit of Canada behind it.

People need not like creative art. It is not a sin if they don't, but they lose an awful lot of joy out of life by not trying to understand it. It opens up a new world for those who seek to understand it. Lots of artists sort of hanker for the adventure of it but are afraid of the public. They couldn't stand up against the sometimes just and sometimes unjust ridicule of the people or the press. They squeeze and little themselves, hoping to please or sell. I tell you it is better to be a street-sweeper or a char or a boarding-house keeper than to lower your standard. These may spoil your temper, but they need not dwarf your soul.

Some say the West is unpaintable and our forests monotonous. Oh, just let them open their eyes and look! It isn't pretty. It's only just magnificent, tremendous. The oldest art of our West, the art of the Indians, is in spirit very modern, full of liveness and vitality. They went for and got so many of the very things that we modern artists are striving for today. One frequently hears the Indians' carvings and designs called grotesque and hideous. That depends on the vision of the onlooker. The Indian used distortion

18

or exaggeration to gain his ends. All nature to him seethed with the supernatural. Everything, even the commonest inanimate objects — mats, dishes, etcetera — possessed a spirit. The foundation that the Indian built his art upon was his Totem. He did not worship it, but he did reverence it tremendously. Most of the totems were animal representations, thus animal life played a great part in the life of the Indian and his art. They endowed their totem with magic powers. In the totem image the aspect or part of the animal that was to work magic was distorted by exaggeration. It was made as the totem-maker saw it — only more so. The Indians were supposed to partake of the nature of their totems. That is to say, eagles were supposed to be daring and fierce, ravens cunning and tricky, wolves sly and fierce. The beaver is expressed by his huge front teeth, his hands usually clasping a stick and his cross-hatched tail tucked up in front of him. These are his most particular and characteristic emblems. They represent him as a brave, splendid creature, an ancestor to be proud of. There is all the difference in the world between their beaver and the insignificant little animal that we take for our national emblem. We belittle him, only give him his surface representation. The Indian goes deeper. He expresses the thing that is the beaver, glorifying him, showing his brave little self that can saw down trees and build his house, energetic, courageous. They show the part of him that would still be beaver even if he were skinned. Here is a striking instance of the difference between Representative and Modern Art.

19

In the next room you will see two different types of pictures. Some will like one kind, some the other, and some neither. The subjects are much the same, but the viewpoint is different. In the older canvases things are carefully and honestly correct as to data. The late Dr. Newcombe, our best authority on West Coast material, agreed to that. The others are the newer school. Here I wanted something more — something deeper — not so concerned with what they looked like as what they felt like, and here I really was sweeping away the unnecessary and adding something more, something bigger.

It is not my own pictures I am pleading for. They are before you to like or to dislike as you please. That is immaterial. For the joy of the artist is in the creating, the making of his picture. When he has gone as far as he understands, pushed it to the limits of his knowledge and experience, then for him that picture is a thing of the past, over and done with. It then passes on to the onlooker to get out of it what there is for him in it, for what appeals to him, what speaks to him; but the struggles, hopes, desires of the artist are all centred on his next problem: how to make his next picture a little better, profiting by his failures and experiences in the last, determined to carry the next one a little further along, to look higher and to search deeper, to try to get a little nearer to the reality of the thing.

The plea that I make to you is for a more tolerant attitude toward the bigger vision of Creative Art — a quiet searching on your part to see if there is sincerity before you condemn.

20

The National Gallery of Ottawa is trying to help the whole of Canada to a better appreciation of art by sending loan collections of both conservative and modern pictures over the country. In the West, modern work was rejected. They were asked not to send any more. How can we grow if we are not permitted to see the progressive work? When other parts of Canada are growing and want to grow, why must we stand still?

When I was young I had a great fear and dislike of monkeys. By and by I came to see this was foolish and I decided to get over it. So I went at every opportunity I got to the London Zoo and I looked the monkeys fairly and squarely in the face. Then I got interested, then fascinated. Now I own one and she has brought all kinds of fun into my life. If Ottawa should send out modern work for us to see, do think of my monkey and remember that tastes can be acquired.

The
Something
Plus in a
Work of
Art

Introduction

*The entry following one dated October 19, 1935
in Emily Carr's journal* reads:* For the last week I
have been struggling to construct a speech. Today
I delivered it to the Normal School students and staff.
It was on "The Something Plus in a Work of Art."
I don't think I was nervous; they gave me a very
hearty response of appreciation, all the young things.
(It hit them harder than the three professors, all
rather set stiffs.) "Something quite different from
what we usually get," they said. The most pompous
person said after a gasp of thanks — "I myself have
seen that same yellow that you get in that sketch,
green that looked yellow. Yes, what you said about
the inside of the woods was true, quite true — I've
seen it myself." Pomposity No. 2, very tidy and rather
fat, introduced himself with a bloated complacency,
"I am so and so" — a long pause while he regarded
me from his full manly height. "I have seen your
work before but never met you." After this extremely
appreciative remark, he added, "Most interesting."
Whether he meant the fact we had not met before
or my talk was left up in the air.

The third Educational Manageress was female. She
said, "Thank you. It was something quite different
from the talks we usually get. I am sure I do not need
to tell you how they enjoyed it — you could see that
for yourself by their enthusiastic, warm reception."
They did respond very heartily. One boy and one
girl rose and said something which sounded genuine,
though it could not penetrate my deaf ear. I could
only grin in acknowledgement and hope it was not
something I ought to have looked solemn or ashamed

**Hundreds and Thousands: The Journals of Emily Carr*,
Toronto, Clarke Irwin, 1968.

over. I was interested in my subject and not scared, only intent on getting my voice clearly to the back of the room and putting my point over. Afterwards I wished I had faced those young things more steadfastly. I wished I had looked at them more and tried to understand them better. If ever I speak again I'm going to try and face up to my audience squarer, to take courage to let my eyes go right over them to the very corners of the room, and feel the space my voice has to fill and then to meet all those bright young eyes. There they are, two to each, some boring through you — waiting. Of course I had to read my talk and that makes all the fuss of spectacles on for that and off for seeing the audience. It must be very wonderful to be a real speaker and to feel one's audience as a unit, to feel them sitting there, to feel them responding, at first quizzically then interested, finally opening up, giving whole attention to what you yourself have dug up, what you have riddled out of nature and what nature has riddled into you. Suppose you got up with a mouthful of shams to give them and you met all those eyes. How you would wither up in shame! What a sneak and an imposter if you did not believe sincerely in what you were saying and were not trying yourself to live up to that standard!

The text of the speech itself (dated October 22, 1935) was among Miss Carr's papers.

26

Something Plus in a Work of Art

Real Art is real Art. There is no ancient and modern. The difference between the two is not in art itself, but lies in environment, in our point of view, and in the angle from which we see life.

The greatness of an artist's work is measured by the depth and intensity of his feelings and emotions towards it, and towards life, and how much of these he has been able to implant and express in that work.

Perhaps one reason for the great and lasting power of the work of the old masters may have been partly their mode of living. In those days a man did not fritter away so much of his time and strength in running to and fro. His attention too was not rushed from one interest and excitement to another as it is in these days. His life was governed by a few strong simple motives. When he attacked anything like art he did so from the depths of his being, from vast reservoirs of stored vitality and ideas based on fundamentals so deeply rooted that they grow and blossom in those canvases still in spite of the time that has passed since their making.

Much of what we call "Modern Art" is, even yet, more "experiment" than "experience." Between the old idea of painting and the new idea of painting, there came a blank stretch, during which much of the meaning and desire for deep earnest expression lay dormant. Something crept in that had not been in the old art. Something which did not touch the roots of art, but floated on the surface with a skin-deep sentimental mawkishness. There were still grand and earnest workers scattered among the artists, but into the real idea of art crept the idea of money rather

than the idea of expressing. Gradually the standard of pictures was lowered. Men painted from a different motive, to get money, to please patrons rather than to express their art. They told stories in paint. They preached sermons in paint. They flattered people in paint. They reminded them by their pictures of places and things that they had once seen, and people went delightedly tripping back through their memories, not in the least stirred by the art in the pictures, but pleased with their recollections of what they had seen with their own eyes.

This was all very well for those that it satisfied, but it was not art, and there were others who craved the real thing, who wanted to go deeper, whose souls revolted within them at the sham, and wanted something inspiring to push forward into. They wanted the power behind the thing — the weight of the mountain, not the pile of dirt with grass spiking the top.

There was a revolt against all this meaningless softness and emptiness of expression, this superficial representation, and the consequence was the "Modern Movement" in art, which was a brave fierce rebellion. It was experimentation — a burning of bridges by these brave ones — a going back to the beginning, with the belief that the fundamentals which the ancients had used were still available to art, if they rooted up all the clogging sentimentality, and dug right down to the base of things, as the simple, earnest workers had done years before.

It was necessary for these pioneers of the Modern Movement to try all kinds of ways and means to

get what they were after. They worked with one eye turned way back towards the simplicity and intensity of the primitives, and the other rolled forward towards the expressing of the tumult and stress of modern life. People laughed at them, called them crazy, and refused to acknowledge the sincerity of them or their work. But they stuck, intent on putting the something back into art that had been lost. So they experimented, tried this means and that, gradually weeding out what did not count, and building onto what did. Even the things that were discarded made their contribution. When they were abandoned it was to give place to something better, but the fact of their being abandoned showed growth, healthy growth that is still going on. You have only to go into a room full of pictures painted in the last fifty years by people who have not as yet come under the influence of "Modern Art" to realize what that growth has been. Of course the movement has its empty shouters, the usual rag, tag and bobtail who follow every demonstration because of the noise and excitement, picking up minor and unnecessary details and passing over the essentials, shouting "Modern Art" meaninglessly, and trying to get, without working and wrestling for it, what the man who has thought long and toiled earnestly has got. But the best of the Modern Movement goes serenely on collecting a very mighty following — it continues to come slowly and surely into its own.

Now there are as many ways of seeing things as there are pairs of eyes in the world, and it is a mistake to expect all people to see all things in the same way.

Also it is a mistake for anyone to try to copy another's mode of seeing, instead of using his own eyes and finding his own way of looking at things. The more you look, the more is unfolded for your seeing, till bye and bye the fussy little unimportant things disappear, and the bigger meanings like power, weight, movement, etcetera will make themselves felt. To express these, it is necessary, as it is in everything else, that the artist should have some knowledge of the mechanics of painting, know how he can produce what he wishes to express. He must know what to look for. He must know what constitutes a picture. Also he must realize what there is in any special subject to produce in him the desire to express it.

A picture is the presentation of a thought that has come to us, either from something we have seen or something that we have imagined. We want to convey the meaning of what has passed through our mind as a result of coming in contact with that special subject. Our first objective must be, however, to pull it forth into visibility, so that we can see with our own eyes what our minds have grasped. If our minds have not recorded anything definite, we have nothing to give.

If we study our subject carefully, we will discover that there was some particular reason why we selected that subject; we either saw or felt something that appealed to us, that spoke more definitely to us than the rest of our surroundings did. It may have been colour, or line, or movement, or light, or texture. It may have been the combination of all these things. At any rate, all these elements must take their places

in our composition, though none of them will be our subject. That will be both hidden in, and disclosed by, these elements. Everything should contribute definitely to it but nothing should overshadow it. The ideal that our picture is built to should transcend all the rest.

Before starting your picture, you first must have a desire, and you must have material; but above all these things, you must form your ideal and build it up. Sometimes the ideal forms itself complete, in a flash, but sometimes you must hunt and hunt, as it were, for a loose end to begin at, then follow it through all its snarls and windings till it comes out the other end of your picture, binding ideas together as it proceeds, until your ideal stands complete before you. The biggest and perhaps the hardest thing in painting is to be true to your ideals.

Suppose six different artists sat before the same subject. Provided they wore blinkers, or did not peep at each other's canvases, but built each according to his own ideal of the subject, carrying it to its fulfillment, it is safe to say that no two of the pictures would be alike — providing, that is, that each had been honest with himself and his ideal.

Undoubtedly it is very helpful to see the work of others, to note what mechanics they have used, what their approach has been, how they expressed themselves, but the real worker must not be too biased by what another artist does. He must strike out and speak for himself, if his work is to be of any real value to himself or to others.

There are artists who force some strangeness that

they do not feel into their work, to make it startling
and original, violently different from that of others,
but this work is not lasting, because it has no
foundation in anything true, and its motive is
not sincere.

The painter passes through different stages in his
work, where the separate elements in the making of
a picture seem to him all-important. These elements
troop before him, obtruding themselves and crying,
"I am the all-important thing that goes to the making
of your picture." We get excited over each phase
as it comes along. Form, colour, composition, balance,
light and shade, rhythm and many more — these all
are important, all have worth, but we must remember
that they are only parts; not one of them is strong
enough to carry the whole burden, to form the base
whereon to build the ideal of our picture. All these
things are superstructure; they must not overpower
the main issue, but contribute to it.

One of the strongest characteristics of the Modern
Movement is the use of design. It is so powerful an
element we are almost tempted to think, "Ha! Now
we have got to the root of the matter. This design
will blend all our elements together. Design will
make our picture complete, so that the eye can travel
all around the canvas, be satisfied, and come to rest."
Very good, that is so, but is that *all* we want? Are we
content to rest in smug satisfaction? To please the
eye alone? A thousand times No. We want
exhilaration. We want incentive to push further on,
we want to make thoughts and longings that will set
us wondering, that will make us desirous to explore

higher and deeper and wider, to see more, to understand more. Design we admit to be an extremely valuable asset to art, but we cannot stop there, stagnating with satisfied eyes; we must go on, because our souls cry out for more.

In preparing notes for this talk I discovered something that I was unaware of. I should not be giving the talk at all because I am only a worker, and workers should work and talkers should talk, and both had best stick to their own jobs and avoid getting mixed up. However, perhaps it is good for us to exchange sometimes, so that each may find the difficulties the other is up against. In this case, by making the effort, I discovered that material that was useable for a talk I gave some years ago was not useable for what I wanted to say today. The facts are the same, but I see them from a different angle. Things that seemed to me of vital importance then seem of secondary importance now. Nor can I find the things I want to say in the art books. They do not seem to be in them, but out in the woods and down deep in myself. Emerson says something to the effect: If I say a thing today, it is no reason that I will not say something different tomorrow. If we did not change we would not grow.

I did, however, come across a chapter in a little book called *How to See Modern Pictures*.* The chapter was entitled "The Something Plus in a Work of Art," and it seemed to coincide with what I was trying to get at. The author said something like this:

Having considered rather carefully that quality in

*How to See Modern Pictures by Ralph M. Pearson, 1925. Dial Press, New York.

pictures which is probably the most vital contribution of the Modern Movement in the world of art today — the quality of organization into design — we must now turn to the "something plus," something beyond the literal content of the picture, something that distinguishes the great work of art.

Further on, he stated that this most elusive of all elements in a picture, this "something plus," is born of the artist's attempt to express the force underlying all things. It has to do with life itself: the push of the sap in the spring, heave of muscles, quality of love, quality of protection, and so on.

And again, quoting from another book, he said that one of the most important principles in the art of Japanese painting is called *Sei Do*. It means the transfusion into the work of the *felt nature* of the thing to be painted by the artist. Whatever the subject to be translated, whether river, mountain, bird, flower, fish or animal, the artist at the moment of painting it must *feel* its very nature which, by the magic of his art, he transfers into his work to remain forever, affecting all who see it with the same sensations he experienced when executing it. It is by expressing the *felt nature* of the thing, then, that the artist becomes the mouthpiece of the universe of which he is part and reveals it unto man through the "something plus" in the picture, the nature as well as the appearance of the life and forms about him. The old masters of Europe, the Chinese and Japanese, the Greeks, the Byzantines, the Assyrians, the African negroes, the Indians of America, and many others through history, embodied this *felt nature* of the

thing in their works of art, and it is when, as in these cases, this divine fire is tempered and controlled by design, that deathless work is born — work that takes its place as part of the universal language of man.

To bring this idea close to home, let us consider for a moment the grand early work of our West Coast British Columbia Indians. Their work has been acclaimed worthy to take its place among the outstanding art of the world. Their sensitiveness to design was magnificent; the originality and power of their art forceful, grand, and built on a solid foundation, being taken from the very core of life itself.

These Indians were a people with an unwritten language. They could neither borrow nor lend ideas through written words. To find means to express, they were obliged to rely on their own five senses, and with these, to draw from nature direct. They saw, heard, smelled, felt, tasted her. Their knowledge of her was by direct contact, not from theory. Their art sprang straight from these sources, first hand. They looked upon animals (through which they mostly expressed their art) as their own kindred. Certain of the animals were more than that: they were their totems and were regarded by them with superstitious reverence and awe. Not being able to write their names, they represented themselves by picturing the particular animal which they claimed for a crest. Every time he pictured this crest the Indian identified himself closer with the creature. To many of the animals they attributed supernatural

powers. People who were of the same crest or totem were bound to each other by closer ties than blood, and did not intermarry. A man did not kill or eat the animal of his totem, but did all he could to propitiate it. He also believed himself possessed of the special attribute of his totem. If he were an eagle he boasted of strength and fierceness. Ravens were wily, wolves cunning, and so forth. The Indians carved their totems on great cedar poles and stood them in front of their dwelling houses; they painted them on the house fronts and on their canoes. In travelling from one village to another, people were assured of a welcome from those of their own totem. Thus the Indian identified himself so completely with his totem that, when he came to picture it, his felt knowledge of it was complete, and burst from him with intense vigour. He represented what it was in itself and what it stood for to him. He knew its characteristics, its powers and its habits, its bones and structure.

Added to this stored-up knowledge waiting to be expressed was the Indian's love of boasting. Each Chief who raised a pole thrilled with pride, and wanted to prove that he was the greatest chief of his tribe. The actual carver might be a very humble man, but as soon as he tackled the job he was humble no longer. He was not working for personal glory, for money, or for recognition, he was working for the honour and glory of his tribe and for the aggrandize-ment of his Chief. His heart and soul were in his work; he desired not only to uphold the greatness of his people but to propitiate the totem creature. The biggest things he was capable of feeling he brought

to his work and the thing he created came to life —
acquired the "something plus."

Once I asked an Indian why the old people
disliked so intensely being sketched or photographed,
and he replied, "Our old people believe that the
spirit of the person becomes enchained in the picture.
When they died it would still be held there and
could not go free." Perhaps they too were striving to
capture the spirit of the totem and hold it there and
keep these supernatural beings within close call.

I think, therefore, that we can take it that the
Indian's art waxed great in the art of the world
because it was produced with intensity. He believed
in what he was expressing and he believed in himself.
He did not make a surface representation. He did
not feel it necessary to join its parts together in
consecutive order. He took the liberty of fitting teeth,
claws, fins, ribs, vertebra, into any corner of his
design where they were needed to complete it. He
cared nothing for proportion of parts, but he was
most particular to give to every creature its own
particular significance. The eyes he always exag-
gerated because the supernatural beings could see
everywhere, and see more than we could. A beaver
he showed with great front teeth, and cross-hatched
tail. Each creature had its own particular things
strongly brought out. The Indian's art was full of
meaning, his small sensitive hands handled his simple
tools with a careful dexterity. He never hurried.

Why cannot the Indians of today create the art that
their ancestors did? Some of them carve well, but
the objective and the desire has gone out of their

work. The "something plus" is there no longer. The younger generations do not believe in the power of the totem — when they carve, it is for money. The greatness of their art has died with their belief in these things. It was inevitable. Great art must have more than fine workmanship behind it.

It is unlikely that any one thing could ever again mean to these people what their art meant to their old, simple, early days. Reading, writing, civilization, modern ways, have broken the concentration on the one great thing that was dammed up inside them, ready at the smallest provocation to burst into expression through their glorious art.